Kid's Dream world
Lovely Imaginations
Simple Thoughts

Arts For Kids to Practice

Blurred Arts as one see in Dreams. Always note
tears, memories, imaginations and dreams blur
the eyes. Sketches, Arts, Design & Colours
seems hazy and unclear as seen in mist
Clouds or in darkness at early dawn.
Making Arts with such effects
is truly a difficult task because
Everything in dreams is hazy
but shining. I wish you all
great success in making
Such arts of dreams.

Aditya Kumar Daga

Dedicated To

My Late Parents & All My Family Members

Special Dedication to All Kids & Children who imagine or dream something strange, remember dreams & love to sketch or do art or make paintings of such imaginations and dreams which they see at night during there sleep.

Art Work sketched, painted & composed By
Aditya Kumar Daga

3C Gopi Bose Lane Kolkata-700012; W.B; India

www. adityaastroworld@gmail.com

Email: adityaastroworld@gmail.com

Mob: +91 9432221255, +91 8961429776

First Edition on 25th September 2016

Copyright @ Aditya Kumar Daga No Part shall be copied or produced or reproduced without the written permission of the Writer, Artist & Author Aditya Kumar Daga

Material Used in Arts

Oils Pastels/Crayons

Wax pastels

Raw Wax

Colour Pencils

Water Colour pencils

Two Pieces of Soft Cloth

Transparent Colours

Fabric Colour-Medium

Linseed Oil

Poster Colours

Fabric Colours

Water Colours

Send me your rare Arts at the above email address with your full details. Rare Collections will be published in next publications just for your reference & fame with your name and addresses.

Process

1. Colour you work Area with oil crayons.
2. Rub softly with soft piece of cloth.
3. Rub wax pastel of similar colour on the same part.
4. Again rub softly with soft piece of cloth.
5. Rub fine thin raw wax of white colour.
6. Rub softly with soft piece of cloth.
7. Make outlines and fill colour with oil pastel.
8. Again rub softly with soft piece of cloth

- Use Water colour pencil at some places to give hazy & smooth effects
- Use colour pencil at some places to give dry & blur effects.
- In some Arts you have to use fabric Colours to give dense effects.
- Some Arts need Poster colours to give distant effects
- A few Arts need water colour simultaneously for water effects
- Use Linseed Oil to give a little transparency
 - Take one drop of oil on cloth & rub softly on required place to give shining effect
 - Take one to two drops of medium on brush of required number and rub softly on required place to give mist and foggy effect.

Aditya Kumar Daga

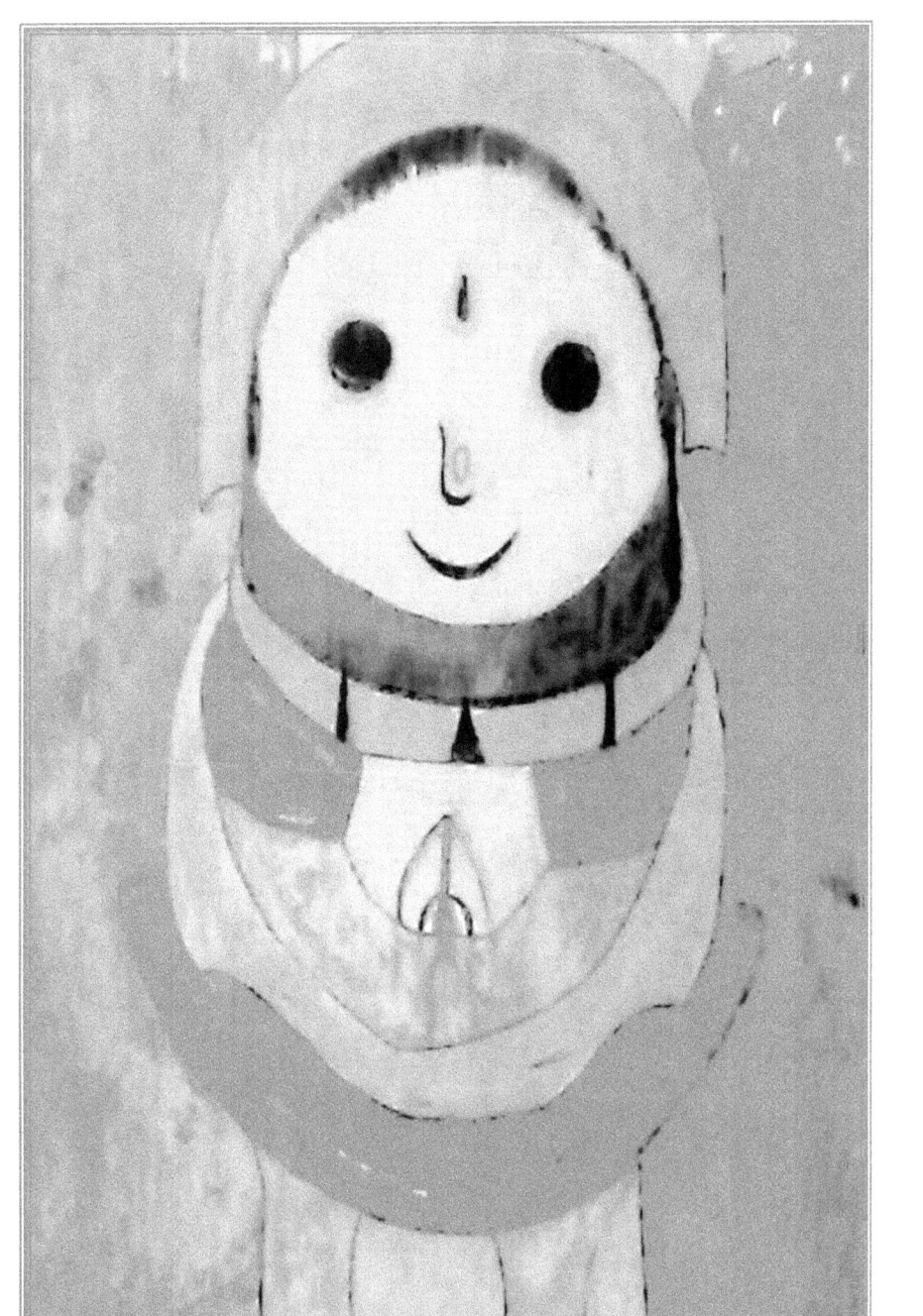

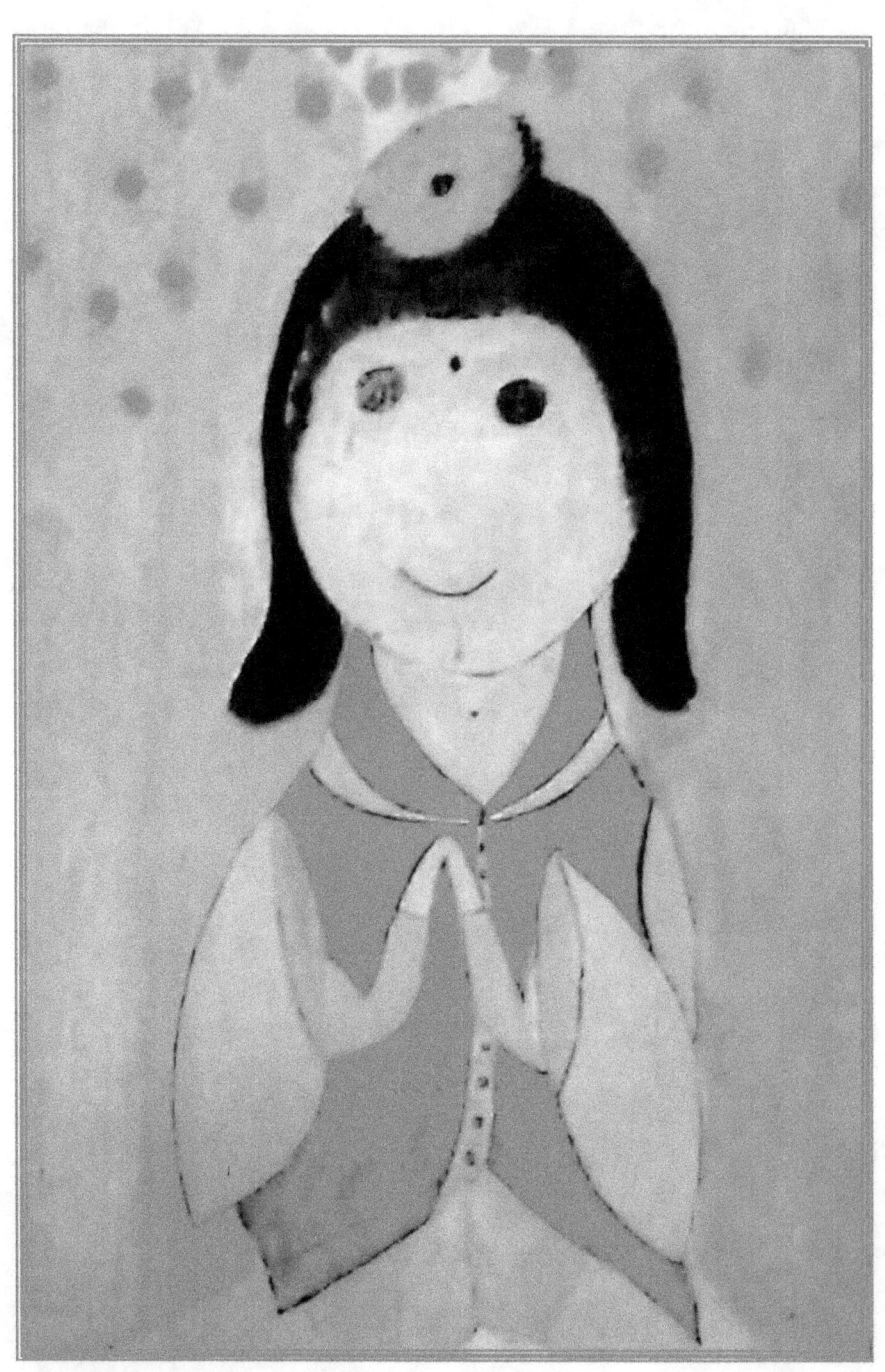

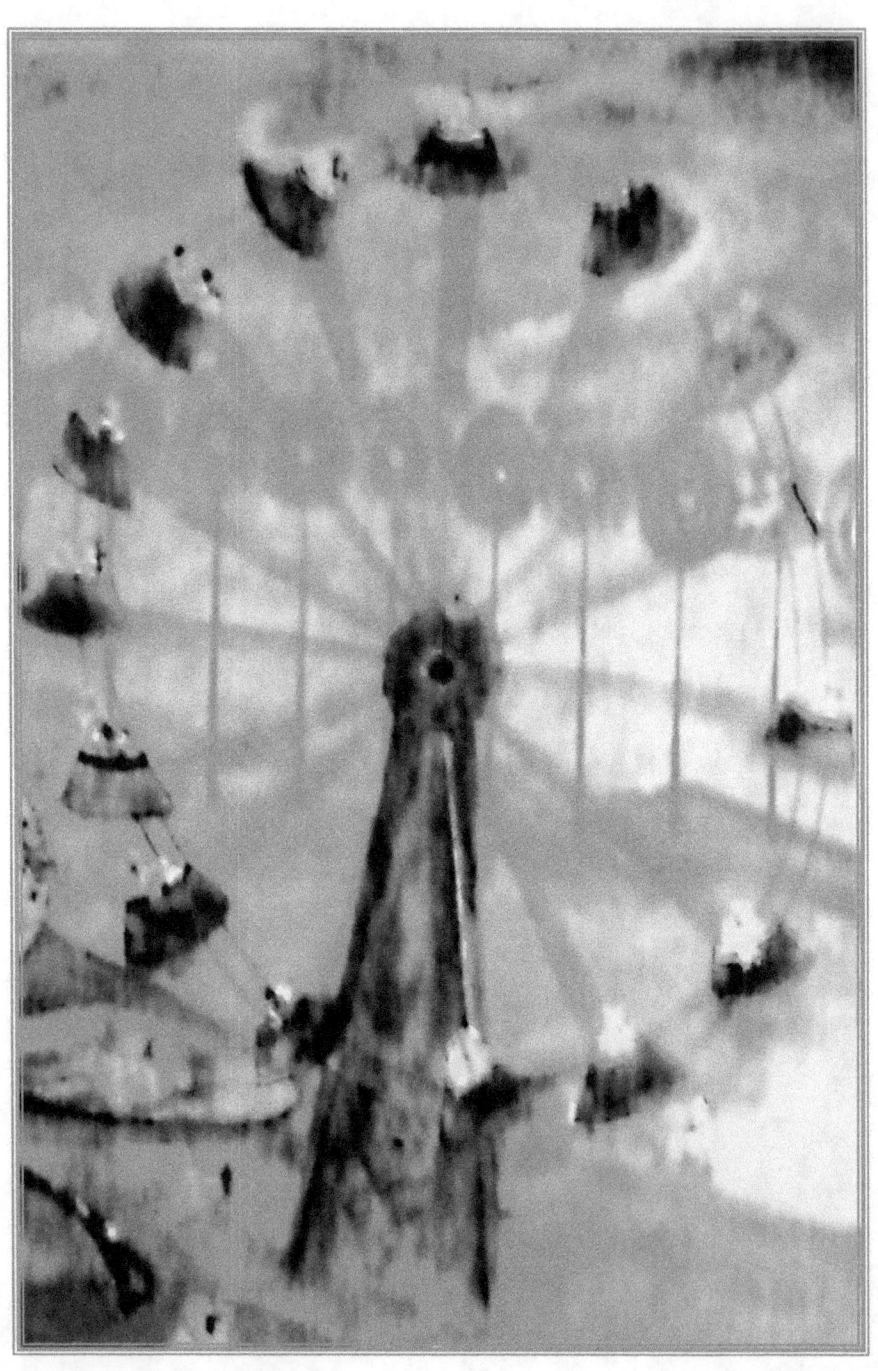

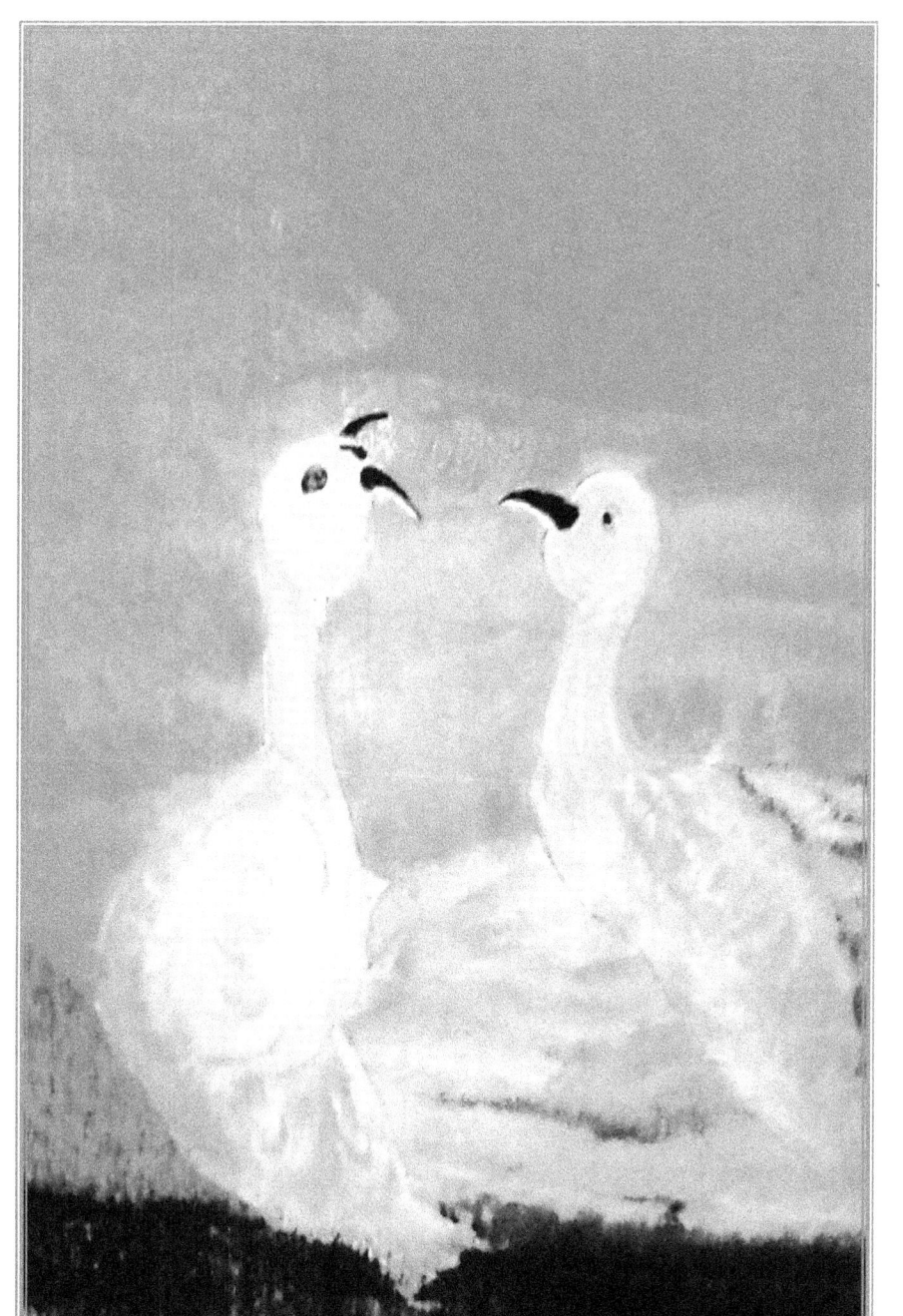

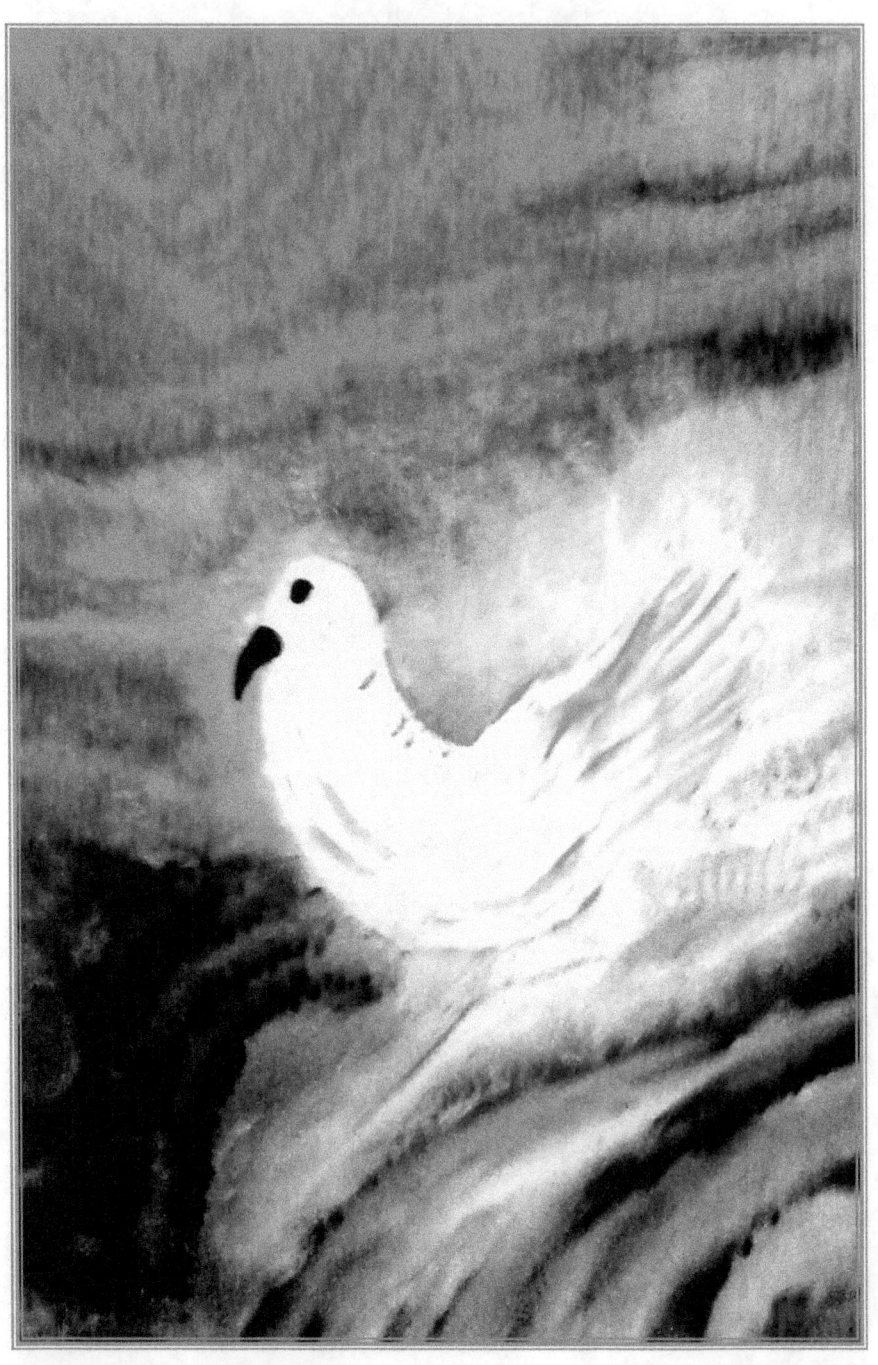

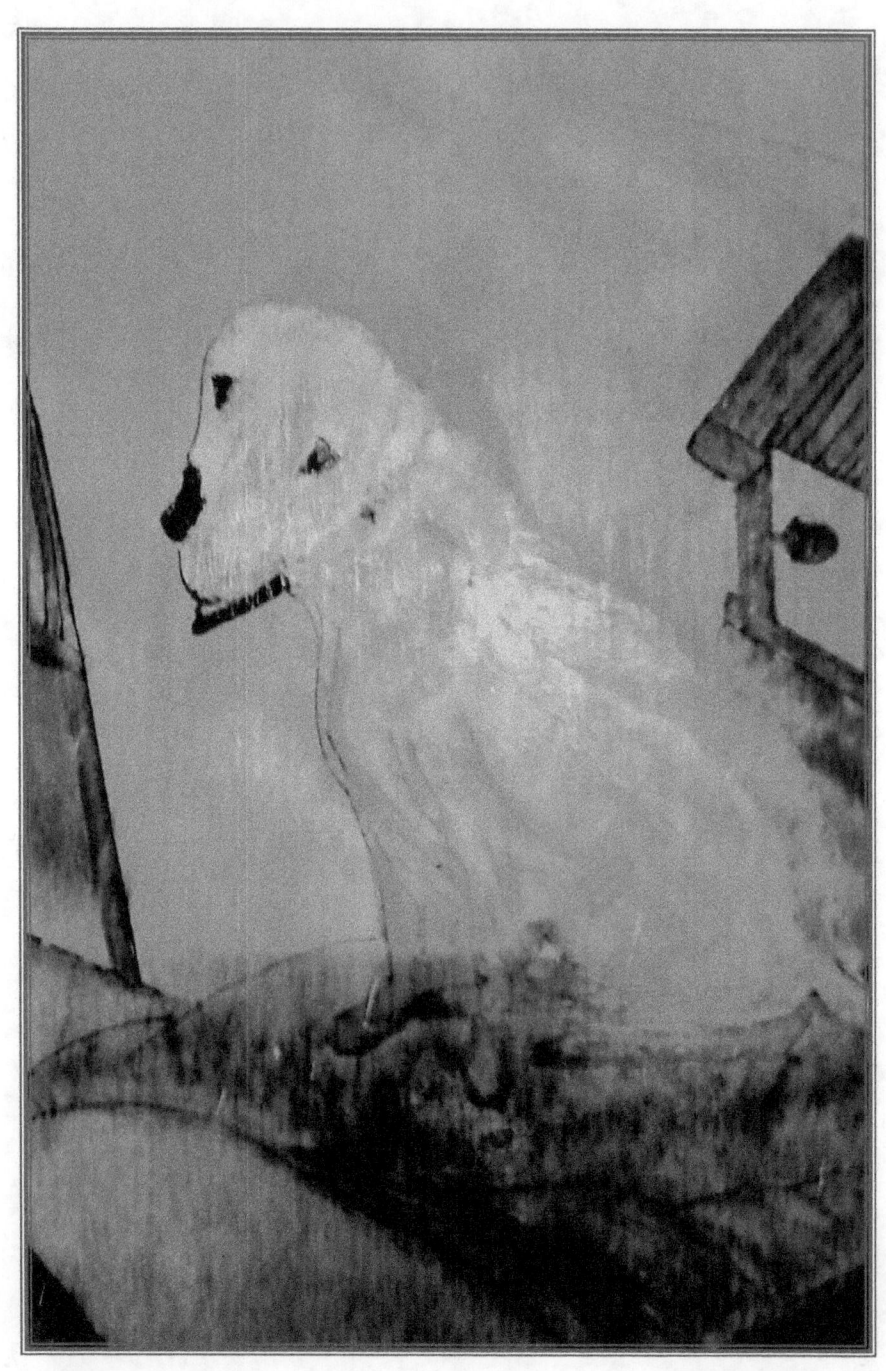

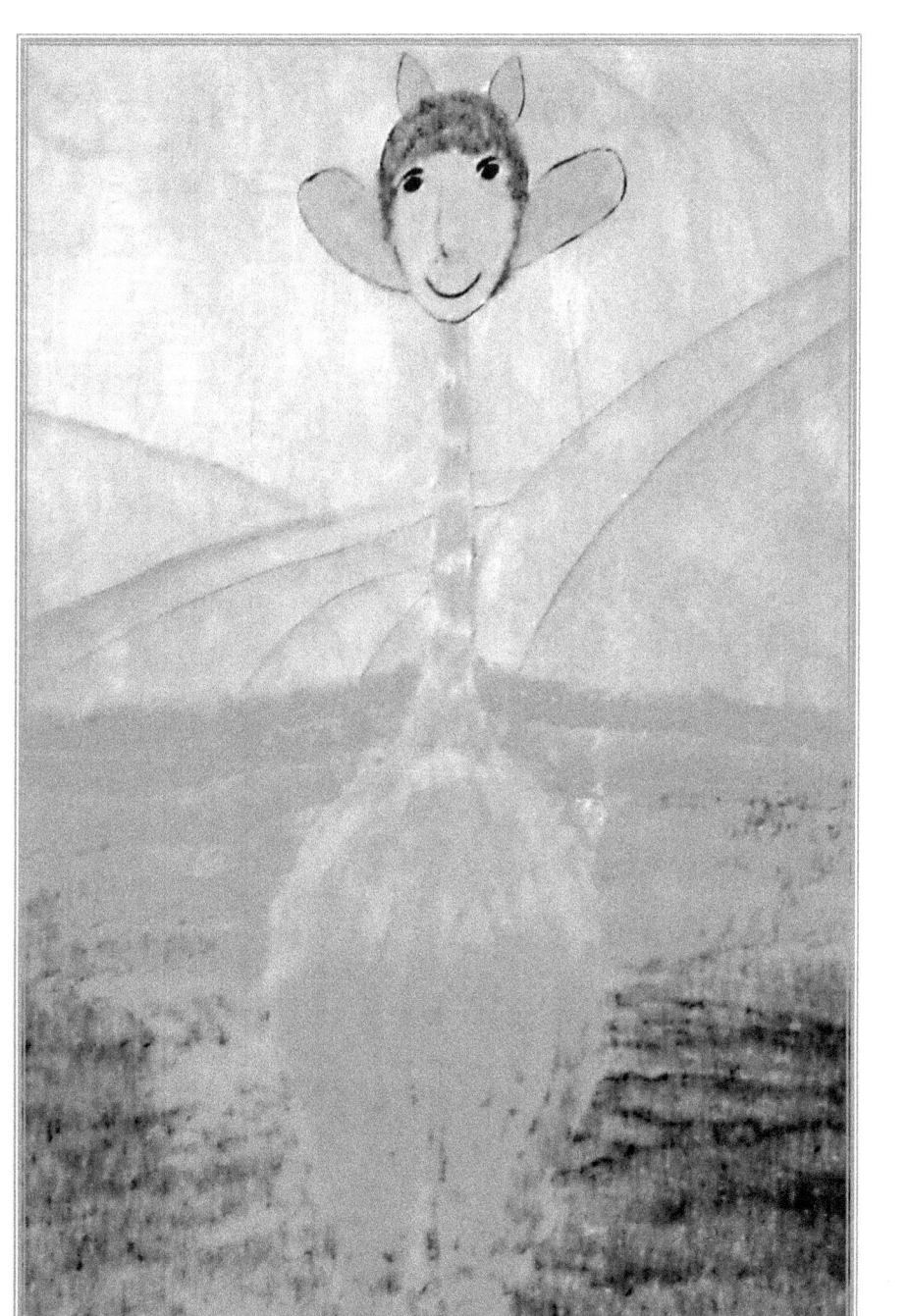

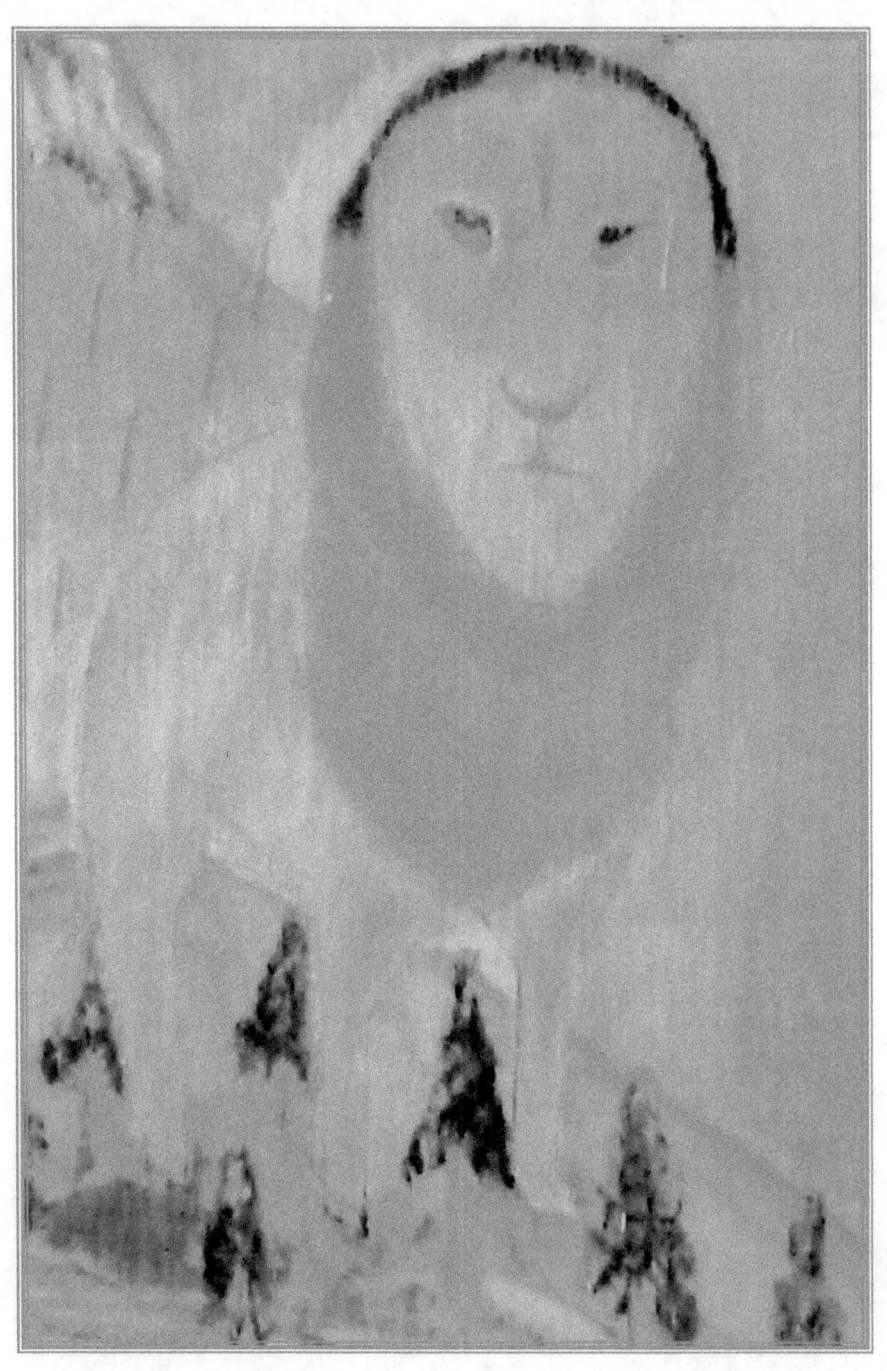

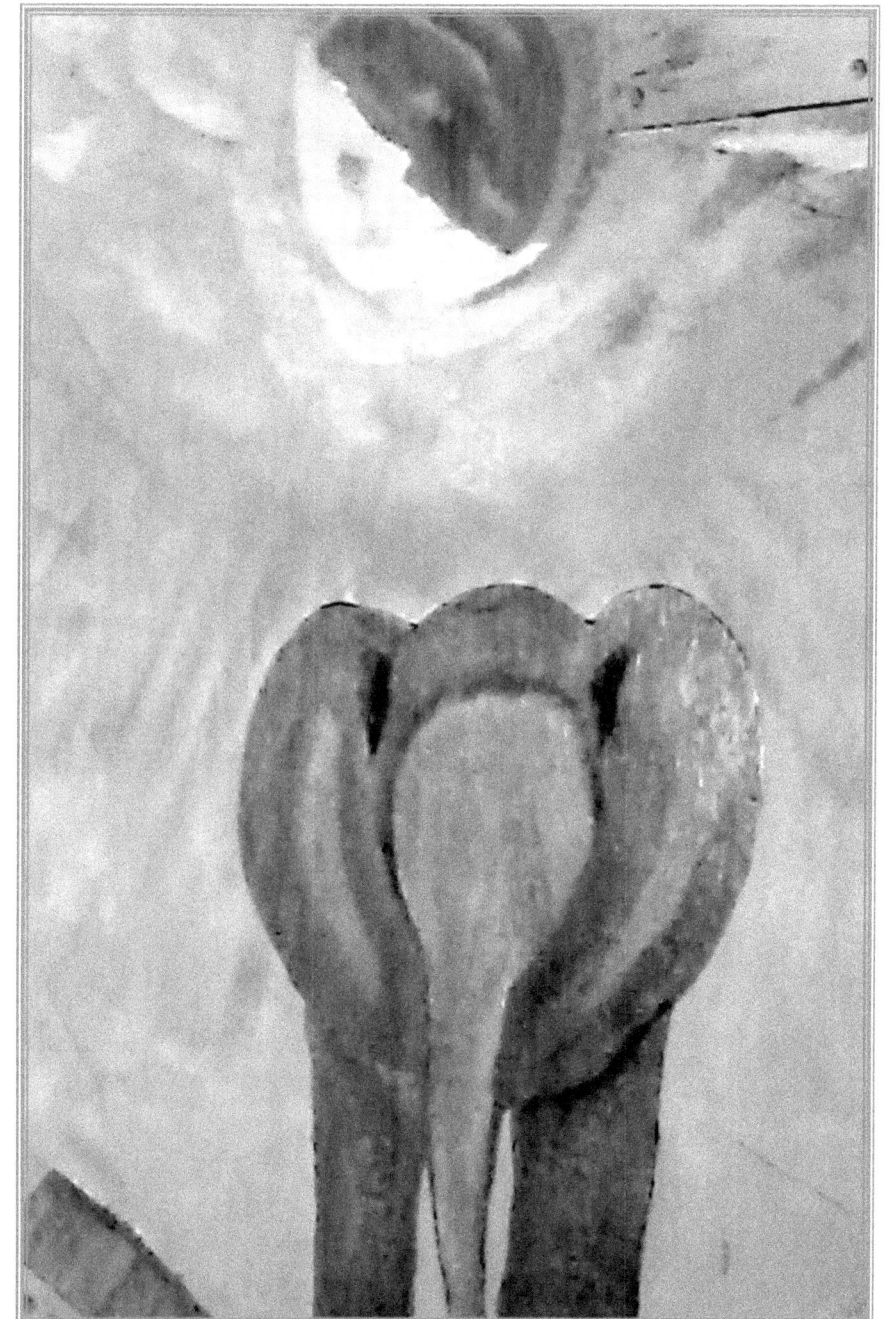

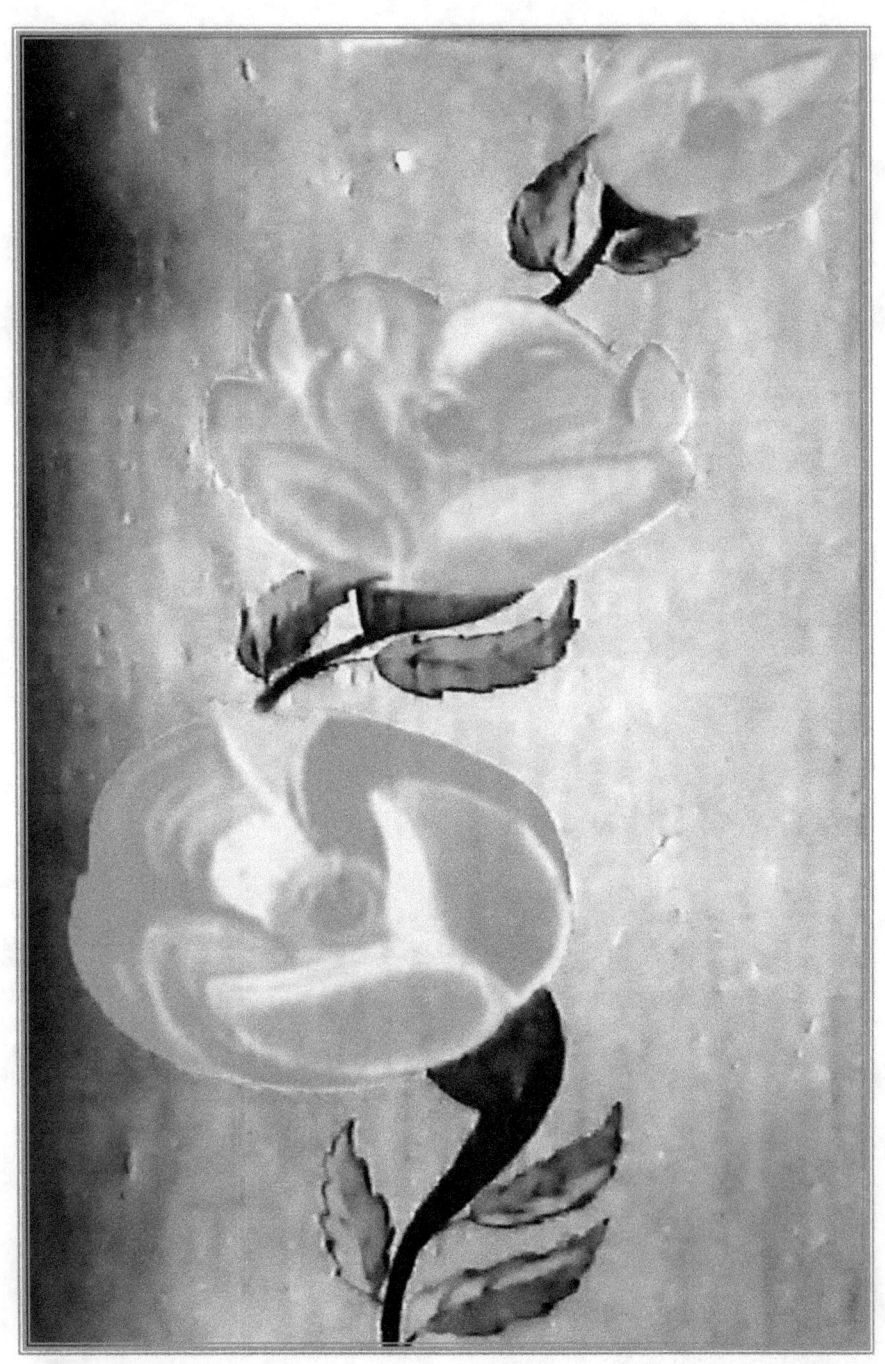

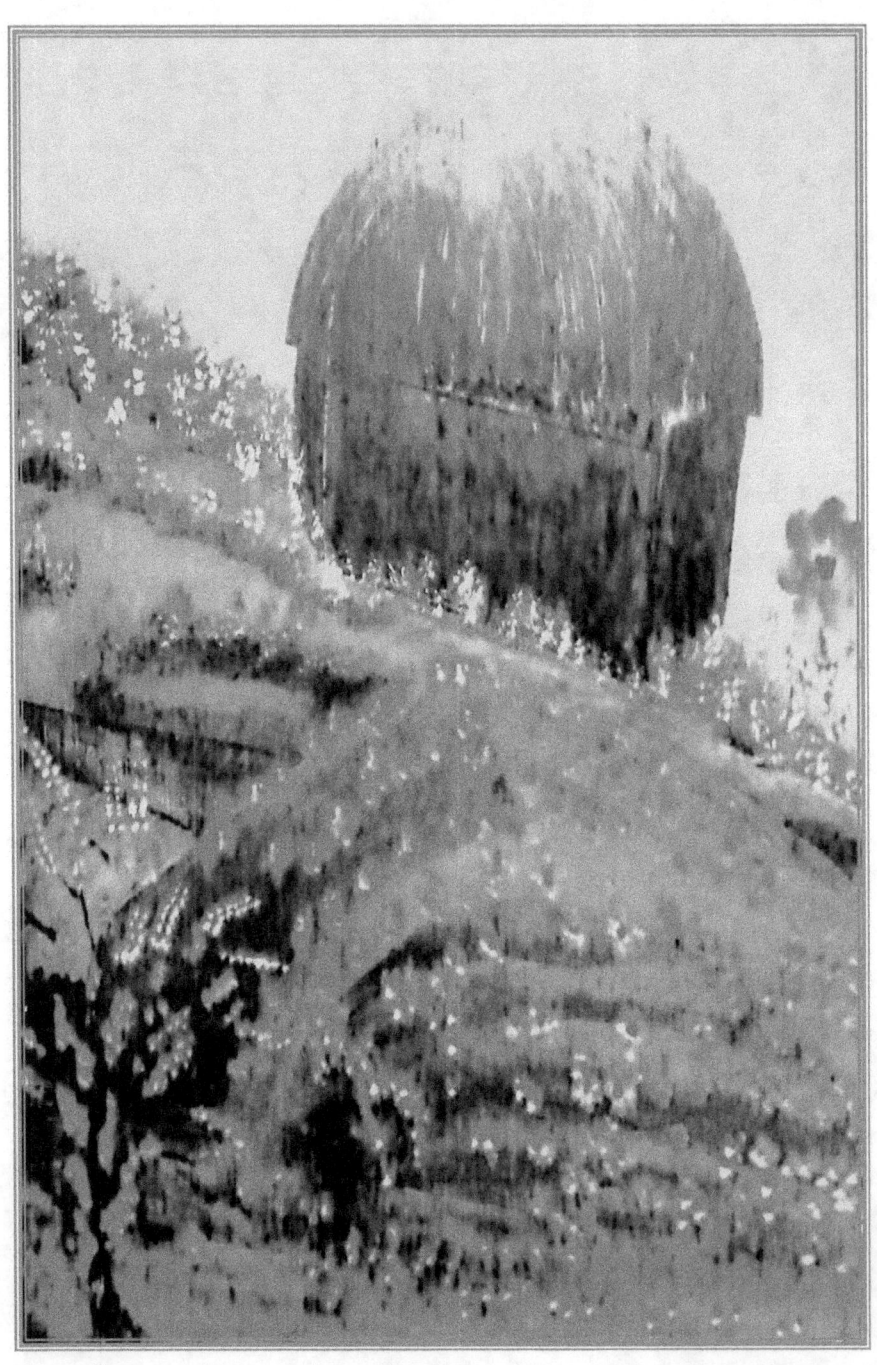

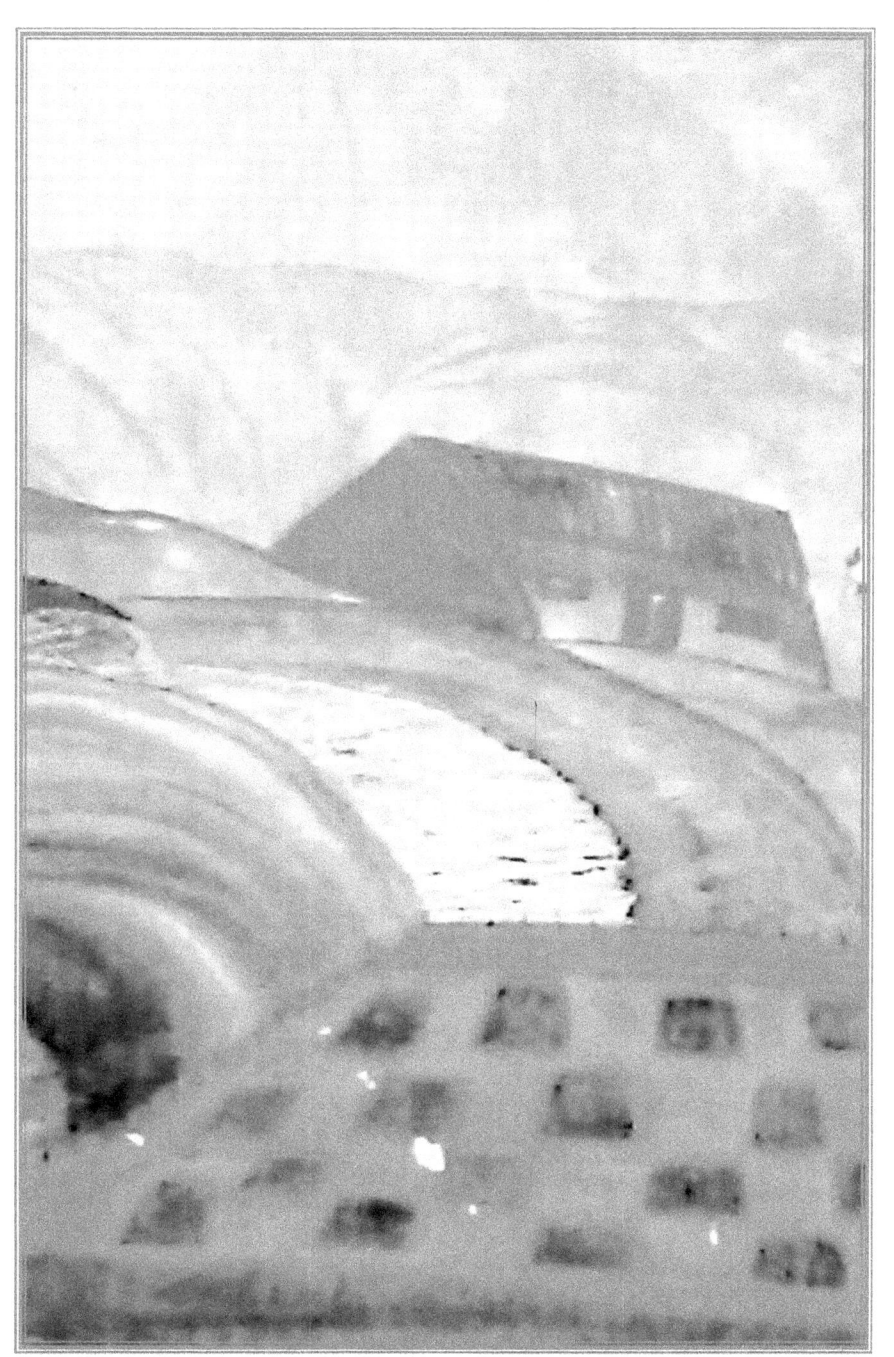

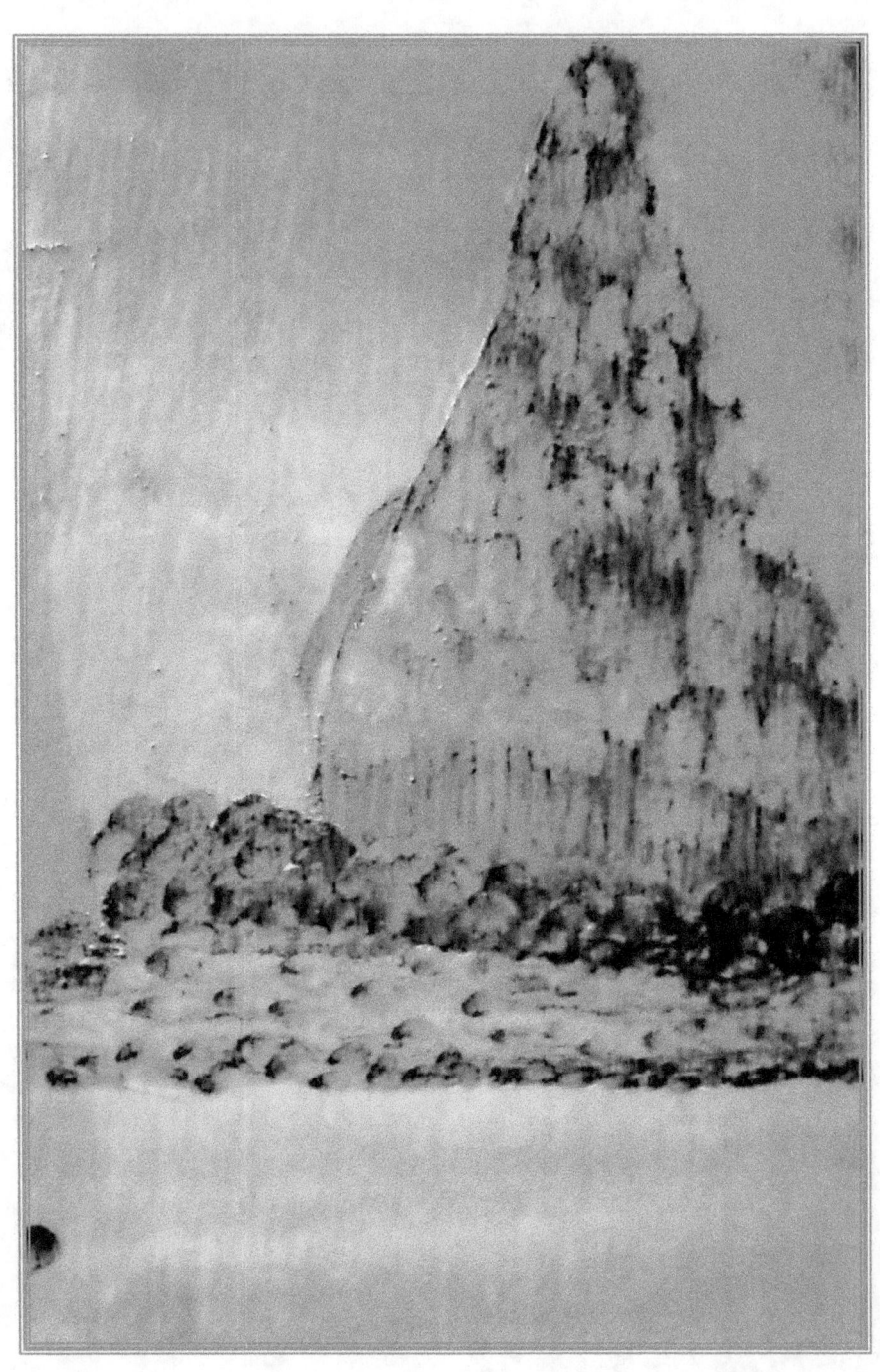

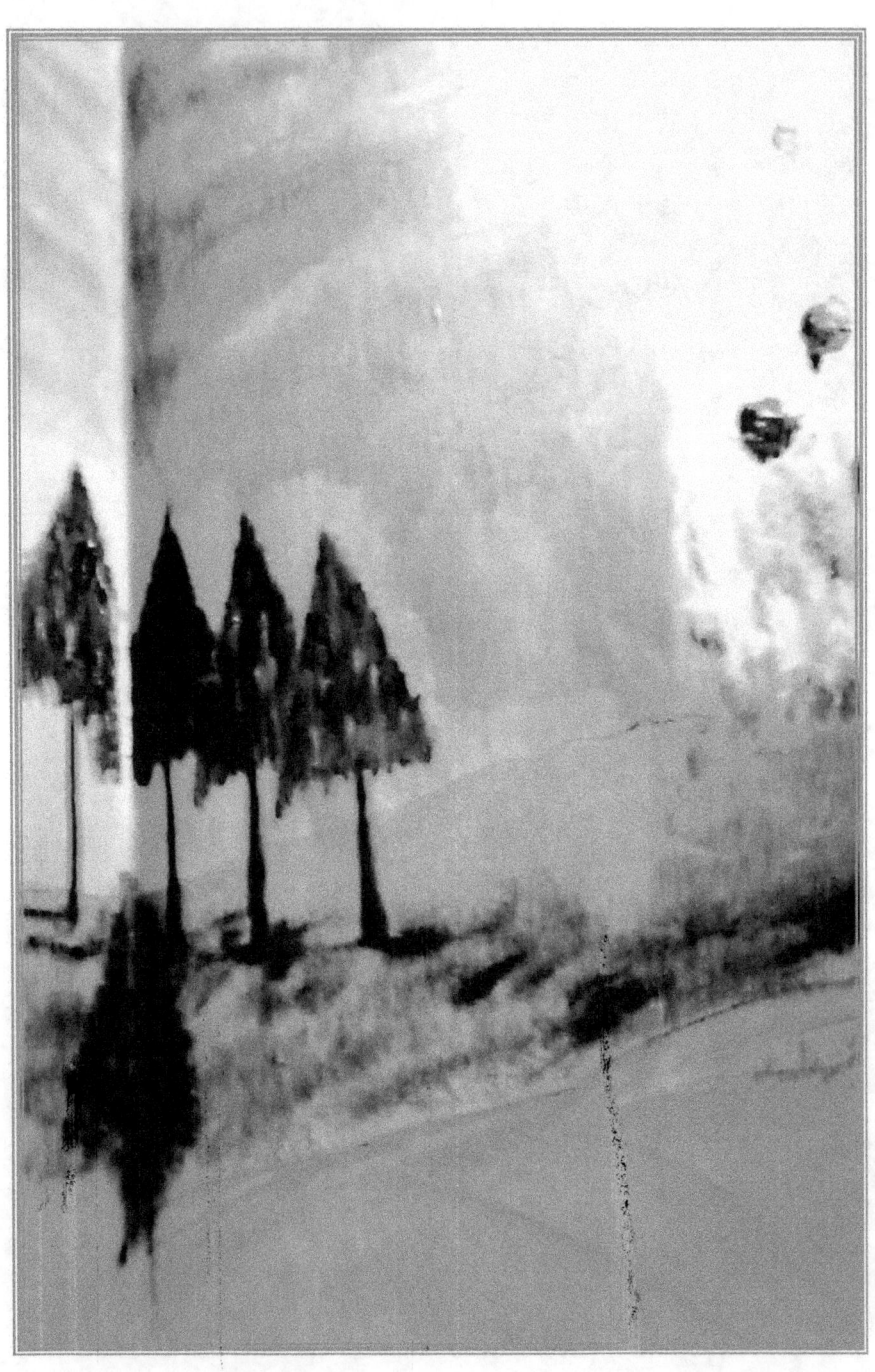

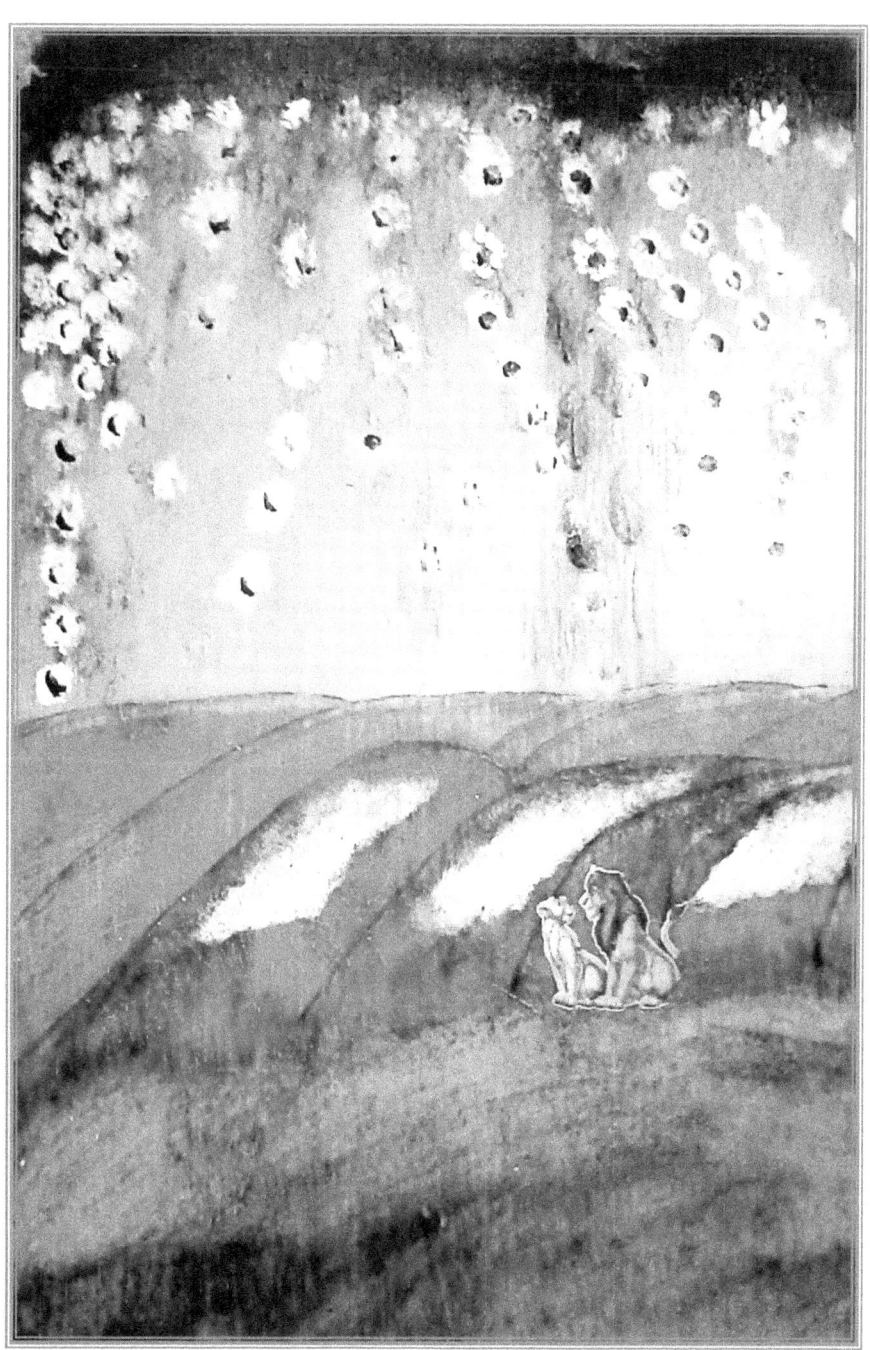

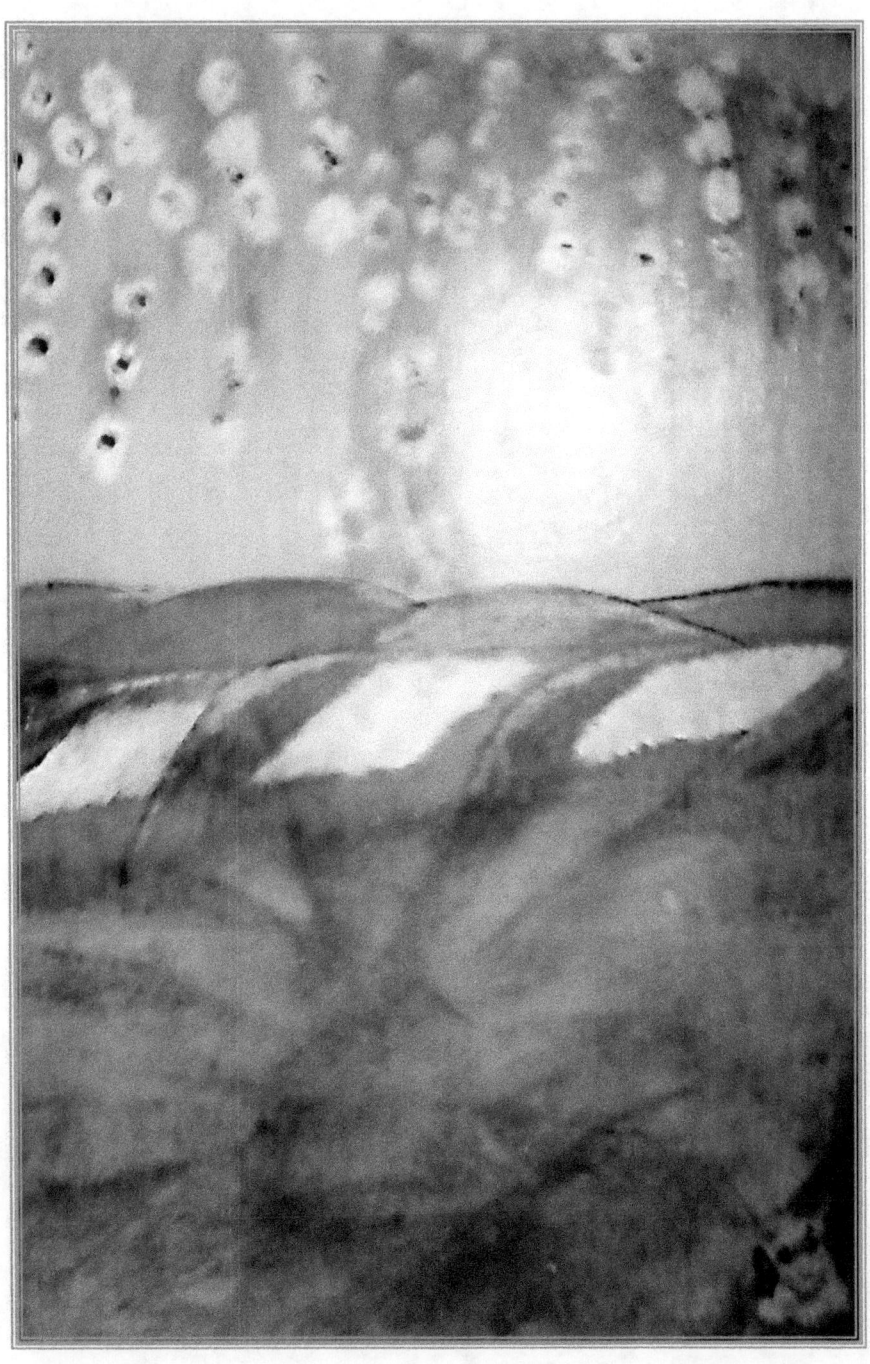

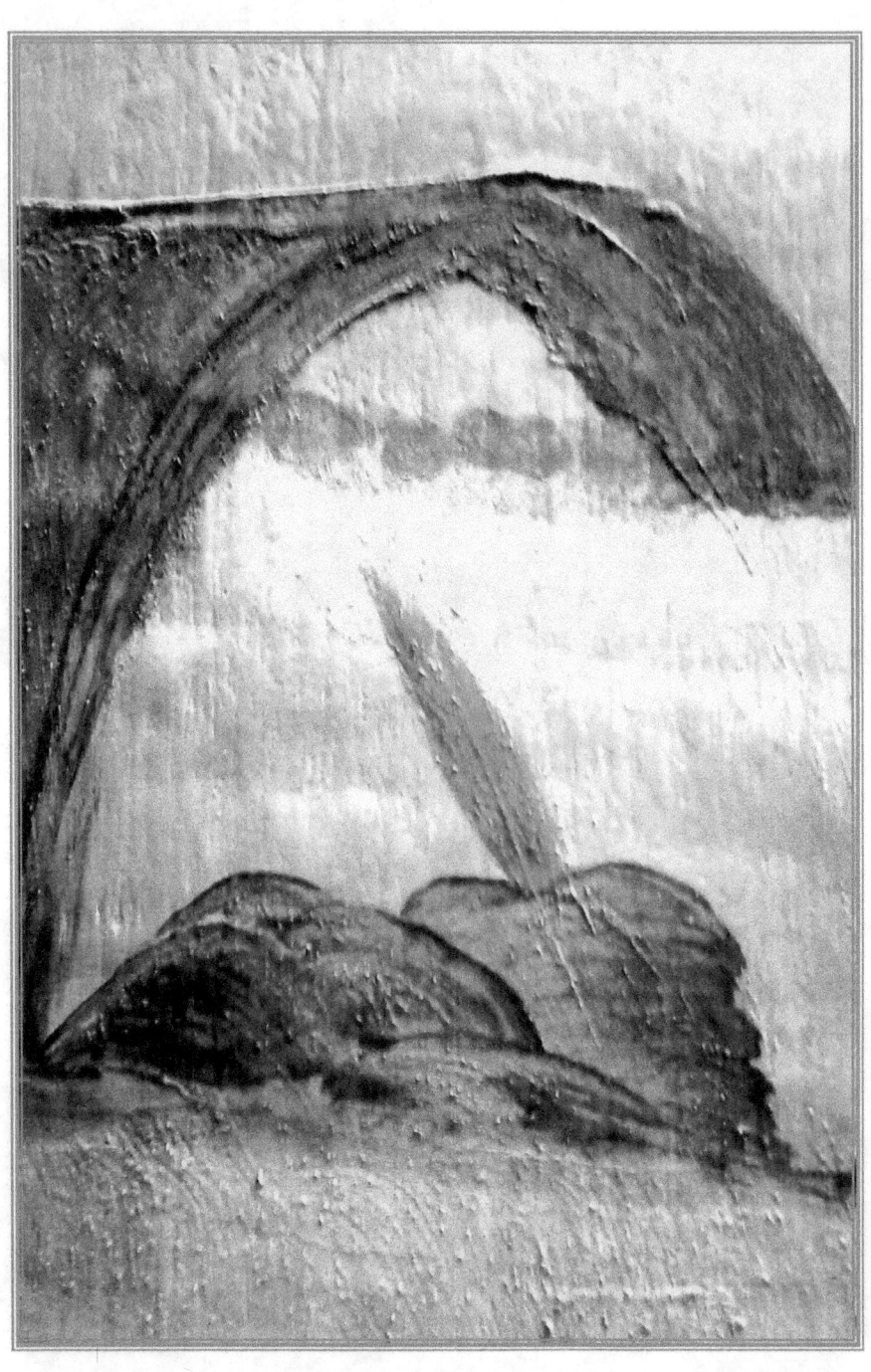

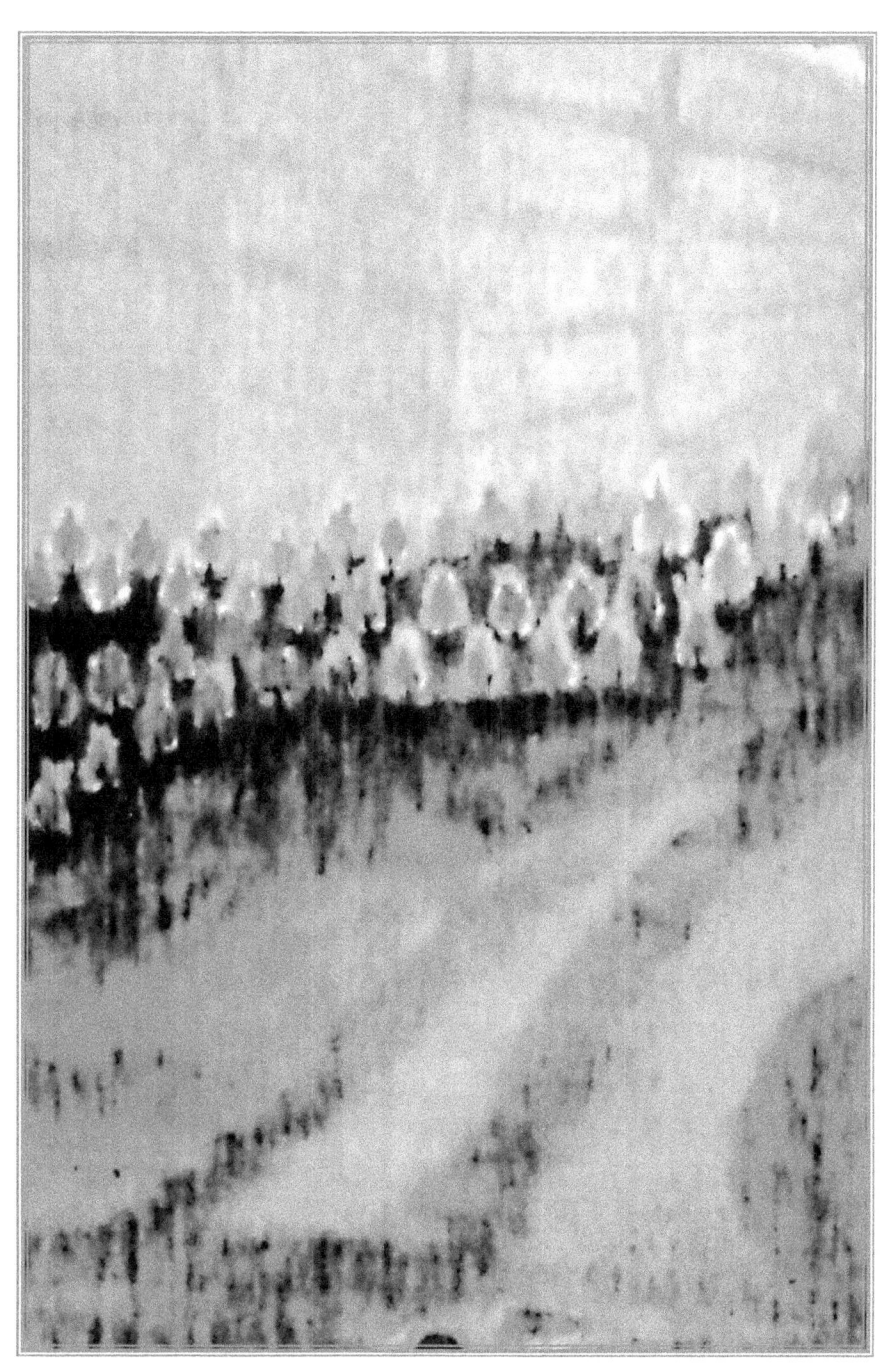

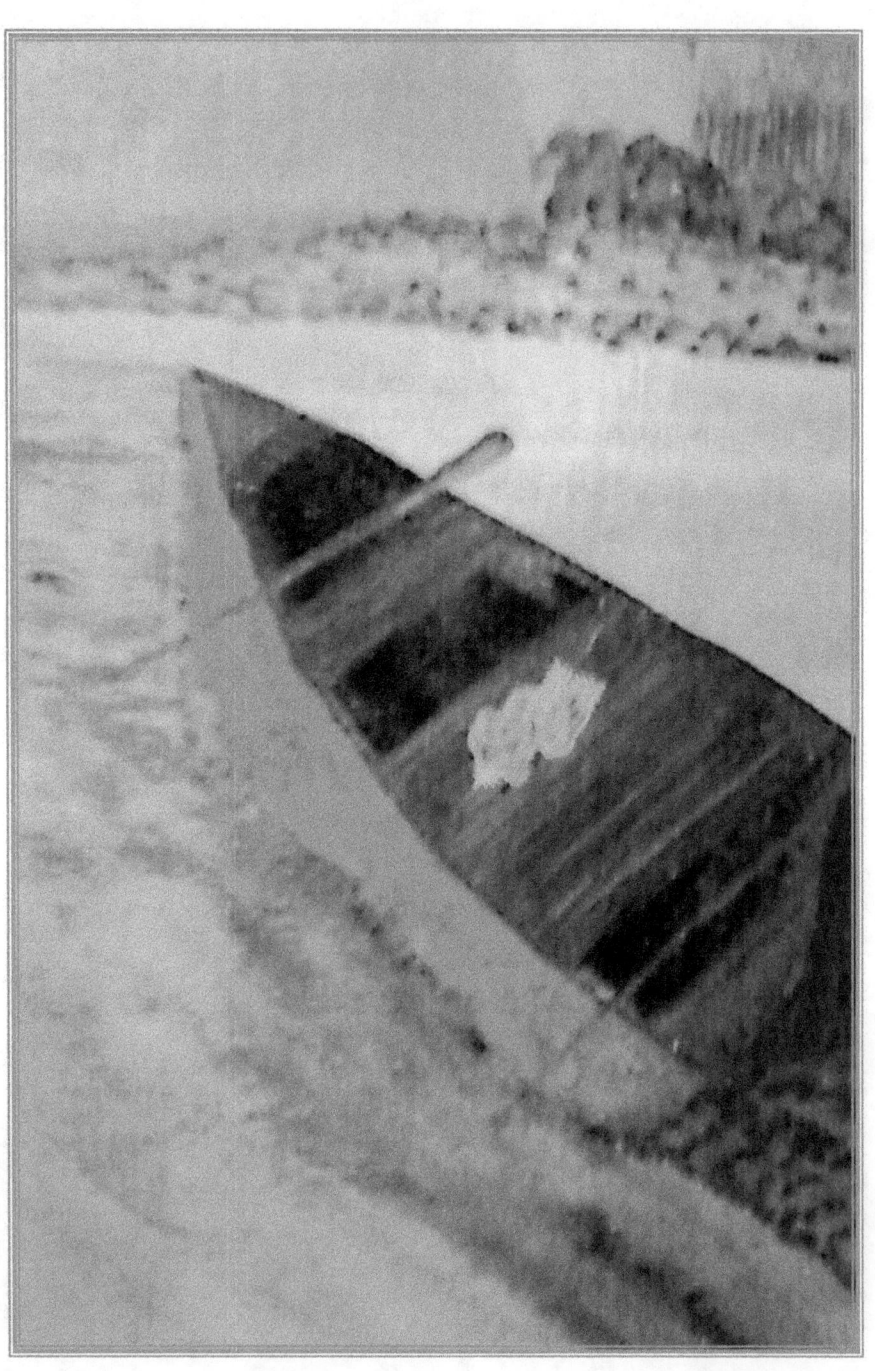

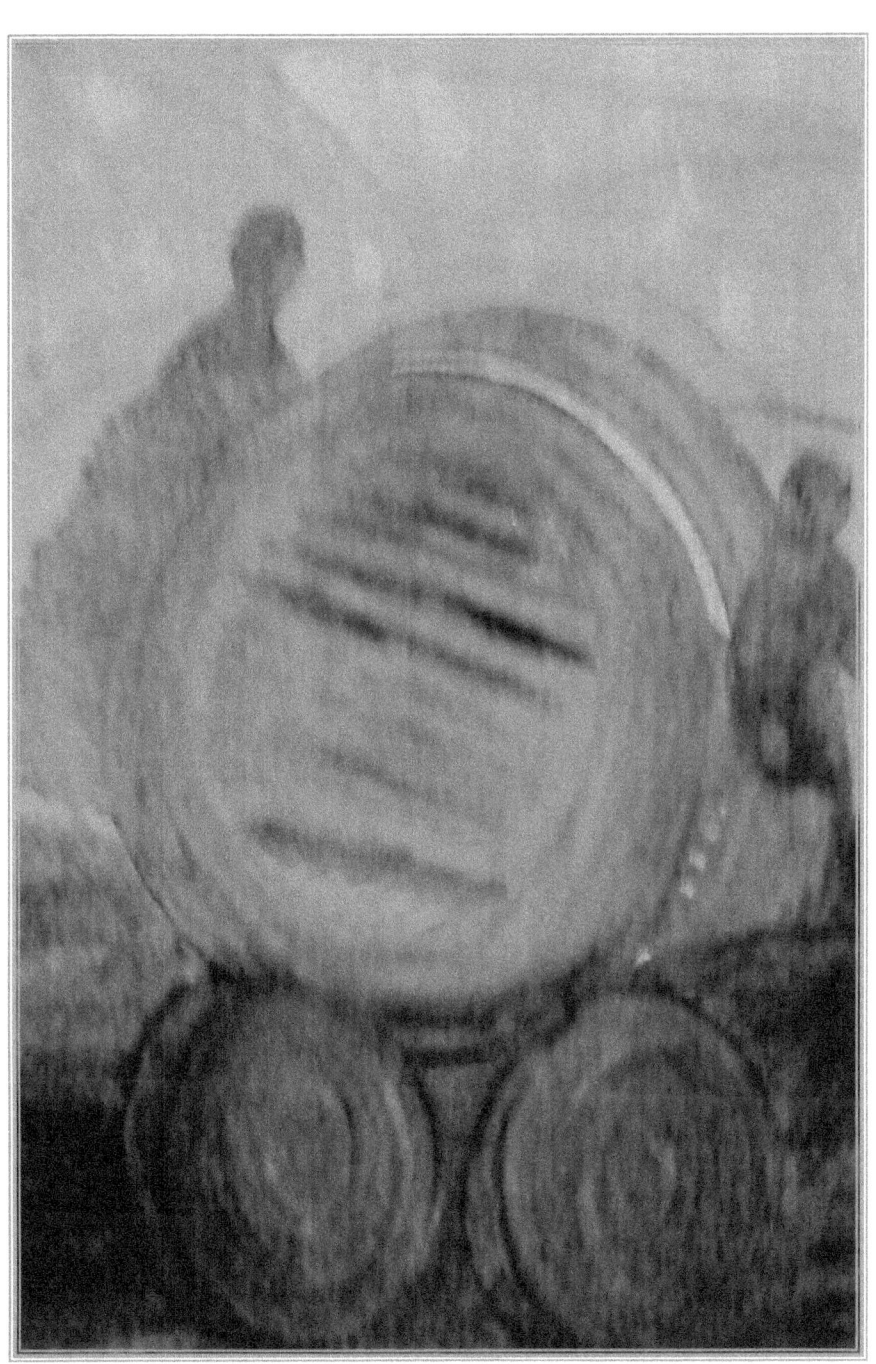

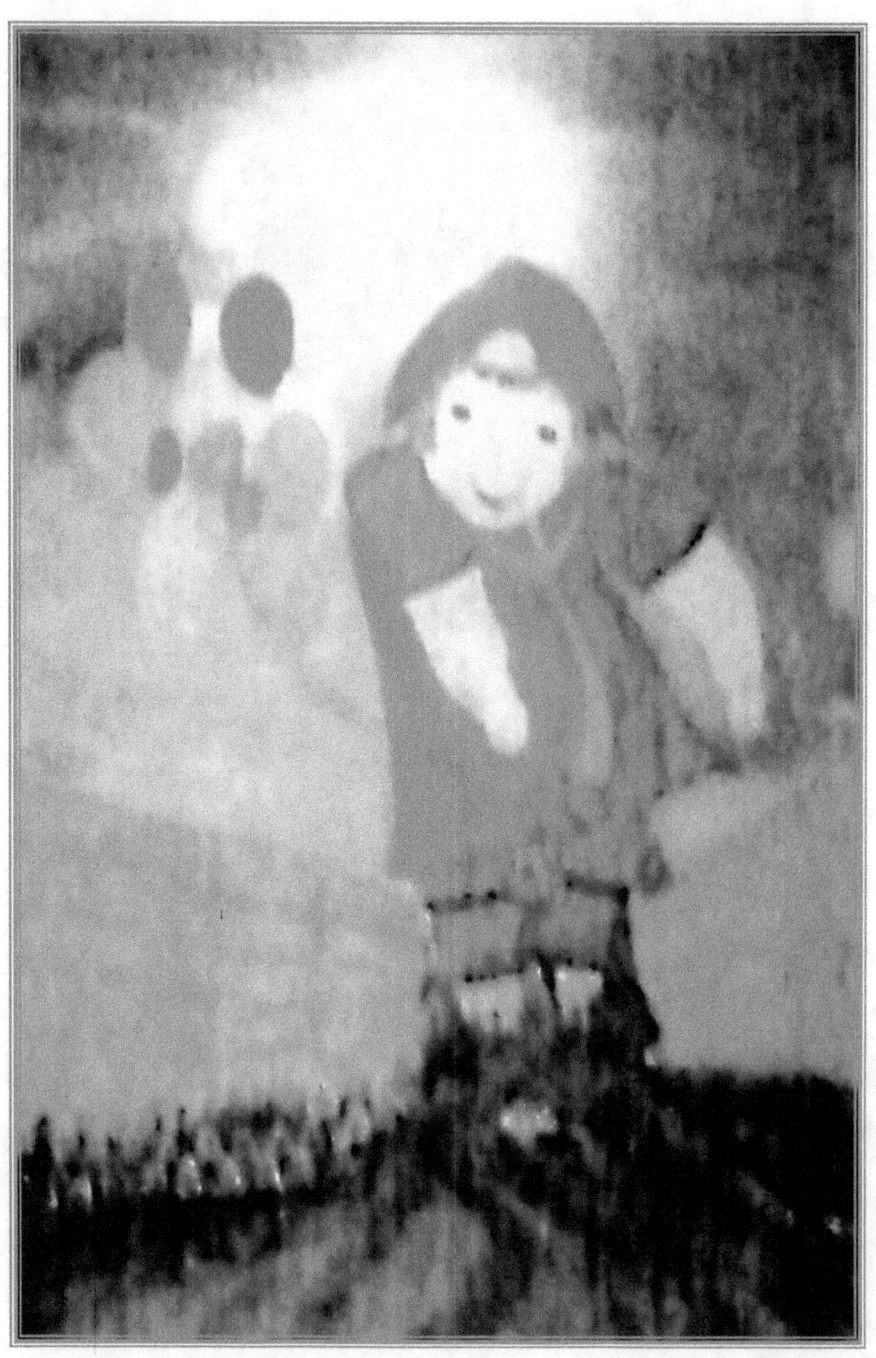

Dear Kid's

Try To be

Simple

Truthful

Loyal

Learner

Loving

Cooperative

Honest

Creative

And A Performer

The world will salute you

By Aditya Kumar Daga

www.ingramcontent.com/pod-product-compliance
Lightning Source LLC
Chambersburg PA
CBHW080525190526
45169CB00008B/3062